Graphic Design: Katharina Riegler
Proofreader: Katherine James
Series Editor: Matthew Koumis
Reprographics by Typoplus, Italy
Printed in Verona, Italy

© **Telos Art Publishing** 2005
Brighton Media Centre
15 Middle Street
Brighton BN1 1AL
England
www.arttextiles.com
editorial@telos.net

ISBN 1 902015 95 9

A CIP catalogue record for this
book is available from the British
Library

Photographers
Malcolm Thomson, Andy Taylor

Artist's Acknowledgments
The Artist wishes to acknowledge:
Professor Sandra Holtby, Head
of London College of Fashion,
University of the Arts London,
for her warm support; and Andy
Taylor for unstinting patience and
assistance; Mary Schoeser and
Christopher Breward for their gen-
erous and insightful contributions.

Notes
All dimensions are shown
height x width x depth.

Page 1:
Walls of Snow and Ice (detail)
1999
silk organza printed with
heat-reactive pigment and
various media
detail 36cm square
of full textile work 54 x 360cm

Page 48:
Grey Water (detail)
2003
silk organza screen-printed
with various media
detail 28cm square
of full textile work in repeat
112cm wide

portfolio collection
Norma Starszakowna

TELOS

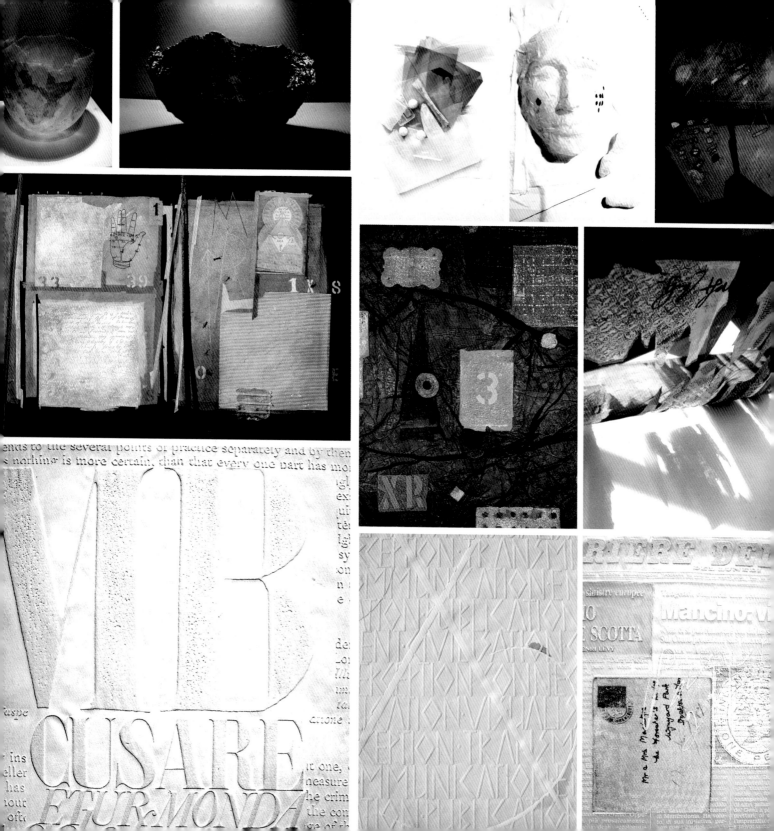

Contents

page 4, from top left to bottom right:
White Bowl, Red Bowl, Medicine Winter,
Spotted Winter, Red Rune Field,
Star Map, Metals, Shard,
Text, Scottish Arts Council Commission,
Communication
1983-93
various manipulations, dye and print media

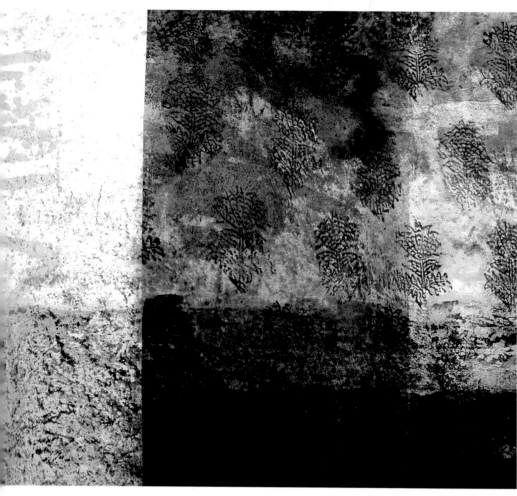

Foreword Christopher Breward

Norma Starszakowna's influential textile works trade subtly yet insistently with the dialectical relationships that link past and future, strength and fragility, surface and depth. In such a manner they quietly embody effects and references that relate both to universal truths and to highly personal experiences. Therein lies their deeply affective power and their ability to segue seamlessly between the sometimes antithetical realms of architectural installation, artistic production and clothing (paying homage to the timeless ubiquity of threaded 'stuff'). In a career spanning almost half a century and touching on many points of the globe, her practice is also almost inseparable from some of the most significant events to have taken place over the same period, both in the intellectual and technical development of the textile arts and on the broader social stage. Like the layered encrustations of those ancient walls that have clearly inspired several of her pieces, dense with inscribed messages and half-erased memories, Starszakowna's developing oeuvre has claimed witness to – indeed has played a central role in informing – important revolutions in printing and dyeing techniques, the reception and understanding of craft as a profoundly politicised endeavour, and the transformation of art and design research into a key driver of the contemporary cultural economy. It is highly appropriate then that the most recent culmination of Starszakowna's career should have been the prestigious commission of *Hinterland* for the new Scottish Parliament building in Edinburgh. Described in *Crafts Magazine* as a 'seductive and celebratory' narrative, constituting 18 silk organza panels that typically combine digital printing, hand painting and embossed detailing, the work moves 'from the depths of Scottish history, illustrated by shadowy dark stone carvings, through blues and greens of land and seascapes to brighter colours of the enlightenment and finally silver', evoking 'a proud and manifold cultural tradition'. It is, without doubt a masterpiece, – perfectly capturing the palimpsest of vistas, events and personalities that constitute a national story. Yet it is also a moving personal testament to a life of risk-taking experimentation and a tacit acknowledgement (suggested both through its ambiguous title and its lambent, ever-changing visual effects) of the inevitable liminality and loneliness of creative labour. Starszakowna has herself remarked (in characteristically unsentimental terms) on the alienating aspects of her line of work and its underlying currents of sadness. That such melancholy and 'unremitting slog' should result in the production of such hauntingly luminous objects is perhaps a painful irony, but it is undoubtedly an irony for which the many who appreciate Starszakowna's work will be extremely grateful.

Christopher Breward
Deputy Head of Research,
V&A Museum, London

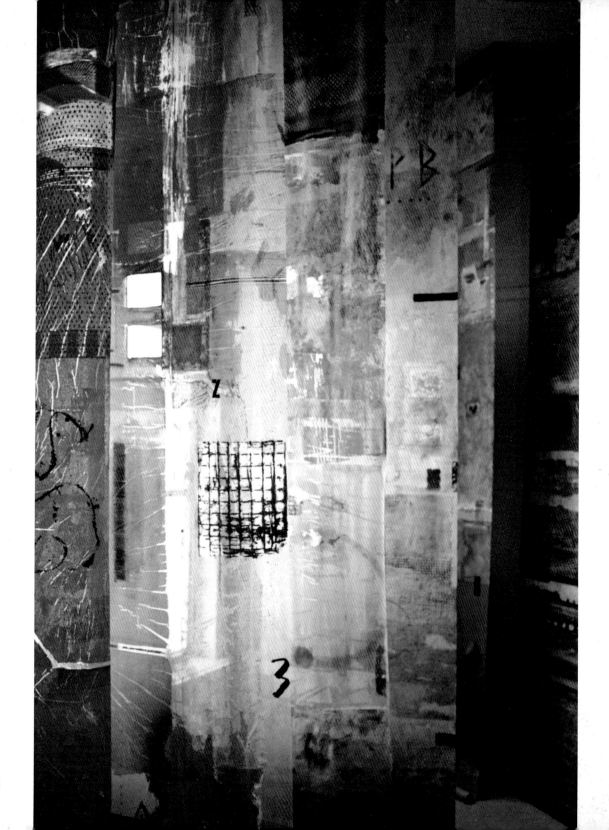

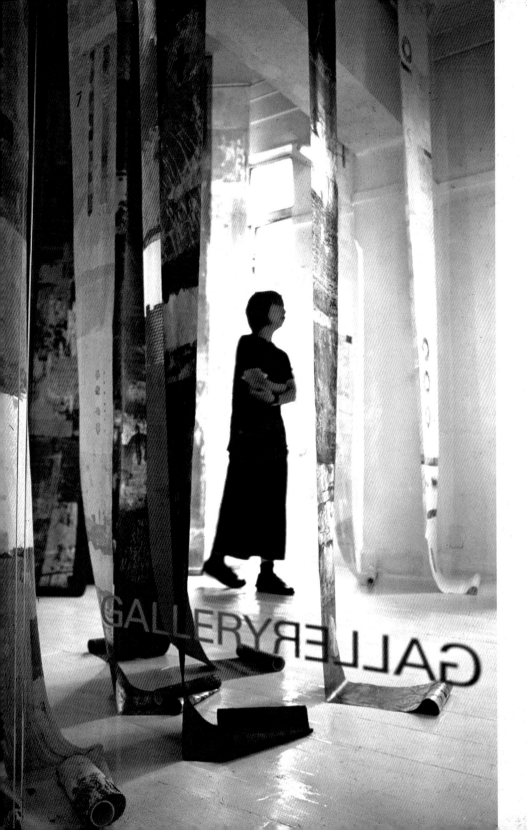

pages 6, 8 & 9:
**Installation, GalleryGallery,
Kyoto, Japan**
1999
all screen-printed with heat-
reactive pigment and various
print media

left to right:
Voices in the Mother Tongue II
Plaster Wall
Pink Pisa Wall
Acts of Beauty III
Rust Graffiti Wall
2003-04
digitally printed silk organza, screen-
printed with heat-reactive pigment,
various print media and oxidisation
54 x 360cm each

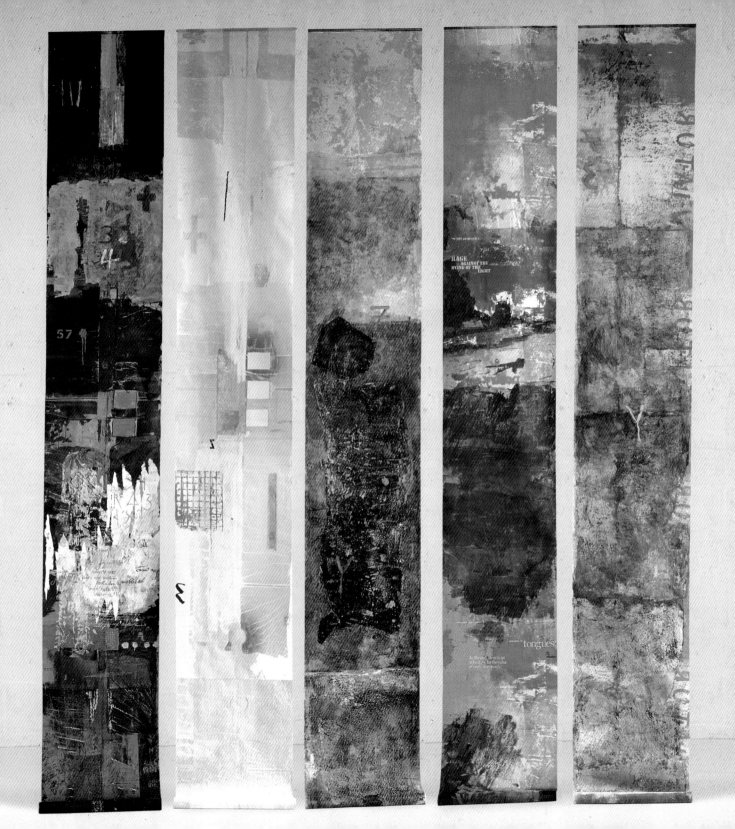

Acts of Beauty

Mary Schoeser

left:

White Crush Print (detail)
1991
white pigment screen-print
on hand crushed white silk
detail 60cm square of full textile
work in repeat 90cm wide

right:

White Crush Text (detail)
1991
heat-reactive screen-print
on double white silk
detail 60cm square
of full textile work in repeat

Norma Starszakowna established her own design studio in Scotland in 1966 and two years later, at the age of twenty-two, had work exhibited in New York. This is the same year in which students occupied the Beaux-Arts Academy in Paris, demanding 'teachers who are with it and know how to teach'. Also in 1968, in New York itself, the Museum of Modern Art exhibited 'Art of the Real', which focused not on representation, but on 'the importance given to material, to structure, to technical methods...'[1] Few in the field of British printed textiles have made such a consistent contribution to these intertwined trajectories, launched in the euphoria of 1968. In this new world of politicized, technique-based art, Starszakowna was a natural inhabitant, having as a child been both buffeted by the fall-out from mid-century politics and drawn to 'the idea of textiles by their omnipresence, their ubiquity from swaddling cloth to shroud and the excitement of new processes and materials'.[2] By 1976 she had begun teaching part-time at Duncan of Jordanstone College of Art, Dundee, where she had trained. In doing so she embarked on a demanding career that embodies to this day the radical optimism of her generation: that creative excellence must be visionary yet bound by societal needs, that it must be equally about the collective and for collective good, however individual its aesthetic may be.

Starszakowna's impetus throughout has been rooted in the exploration of three-dimensional surface qualities accrued during the colouration of cloth, a practice recognized as her forté as early as 1977, when she received a Scottish Arts Council Award for research into new processes. She was already a master of freehand wax-resist drawing – or batik – in which the nuances of shading and layering of tones were exploited to produce a depth both textural and, by illusion, spatial. To this skill she added photographic silk-screening methods and experiments with iron filings and salt as over-dyes, all to add further layers of intricacy.

details from top left to bottom right:
Rovaniemi Runway (detail)
Plaster Wall (detail)
Snow and Ice (detail)
White Strip (detail)
1999-2004
various silks, printed with heat-reactive pigment, print media
and patinated
detail 30cm square
of full textile works 54 x 360cm each

SPEAKING IN

tongue

In the end, there is no
substitute for the value
of one's own words

Her foray into vessel-making in the early 1980s demonstrated the same sensitivity to the subtleties of graduated densities. Created, papier mâché-like, with pre-printed and cut silk and acetate 'shards' laminated with several coats of resin varnish, seemingly fragile bowls belie the inherent strength of silk and at the same time display complex tonal and surface qualities.

Complexity is perhaps the single best word to describe Starszakowna's oeuvre, as well as the artist herself. The dualities of strength and fragility run as constants throughout her personal history as well as her accomplishments in the intertwined arenas of textiles and teaching. Taking the prize-winning *Silk Wall* (1981-83) as an example of the former, this ten-section installation (commissioned by architects J. Parr & Partners for the world headquarters of General Accident Assurance Company in Perth, Scotland) is bold in conception and yet delicate in execution. Composed of different weights and textures of silk panels, across it are disposed cyphers and symbols of ancient and current cultures, the aboriginal and the industrial or, one might say, the endangered and the endangering. The realization of this subtle commentary on globalization involved experimental and innovative methods such as a crush-spray technique. The visual residue of crushing is familiar to all who use wax-resist techniques, because the wax will crack if the fabric is twisted or scrunched during immersion in a dye bath. But Starszakowna took the resulting 'crazed' surface and moved on to explore more extreme treatments in which the crushing is rendered permanent. By the early 1990s, the ensuing textiles varied widely, ranging from the rich tones of pigments printed on black crushed organza in *Metals* (1993) to the embossed *Crushed Text* and the all-white pigment-printed *Crushed White* of 1991-93, which respectively pioneered unique processes of bonded layers and pigment prints on shibori-crushed substrates – the latter among the innovative concepts selected by Issey Miyake for vestments

Voices in the Mother Tongue II
(detail)
2003
silk organza, printed with heat-reactive pigment, various print media and metal leaf, cast
detail 45cm square
of full textile work 54 x 360cm

Starszakowna had 'unfussily established herself as a charismatic and demanding leader, teeming with insights...' but that the 'distinction of her work has been reached by an aching route'. Starszakowna herself commented on her banner, *Standing in the Sachem Door* (1995), that 'if you are dealing with people, it's helpful to have experienced some hardship and sadness so that you can detect and understand it in others, even before anything is voiced.'[9]

The visual expression of this collision of the strong and the sensitive is facilitated by Starszakowna's acute receptiveness to the texture of life, whether emotional or environmental, and expressed most consistently in the collage-like arrangement of her imagery and in those bruised, broken or tarnished surfaces. While compositions of the mid-1980s, such as *Medicine Winter* (1986), are genuine collages of resist-dyed and hand-formed silk pieces, Starszakowna was also using the resist technique alone to achieve the illusion of depth and

juxtaposition. With the addition of printing and rusting, the culmination of this series of resist-dyed wall pieces is represented by *Star Map* (1993), in which the depiction of tenderly preserved, brittle pages is a *tour de force* of spatial illusion. The significance of text, letters and numbers in addition to the seemingly torn, distressed surfaces, is their explicit reference to her life-long immersion in 'otherness', a condition rooted in her Polish-Scottish response to English colonialism and an observant eye born out of a childhood of alternating isolation and memorable treks with her father. When she was aged around six or seven, he would leave her for hours in the countryside in Fife, where she absorbed the silence, the signs of animals and the remnants of human intervention in the still-smoking bings of derelict mines, and found comfort in a sense of unity with the earth. Interlaced in these early memories are those of battered and poster-strewn walls – so vividly evoked in *Shards* (1994) and *Graffiti Wall* (1993) – where, by standing on her

father's shoulders, she was able to pin up his political pamphlets beyond the reach of everything but the physical and semiotic erosions of time itself. These brief interludes presaged a long period of darkness and her father's eventual return to Poland, but out of this concoction comes Starszakowna's powerful connection to the socio-political potency of calligraphic symbols and graphic ephemera of all kinds, from Celtic runes and Native American pictograms to Soviet propagandist script. That her alphabet goes beyond the individual typographic form to a visual language of her own is confirmed by her attitude to a stock of screens now numbering about 60. These she uses interchangeably, literally collaging with them, to produce the multifarious interplay of voids

Voices in Mother Tongue II (detail)
2003
digitally printed silk organza, screen-printed with heat-reactive pigment, various print media and oxidisations
detail 30cm square
of full textile 54 x 360cm

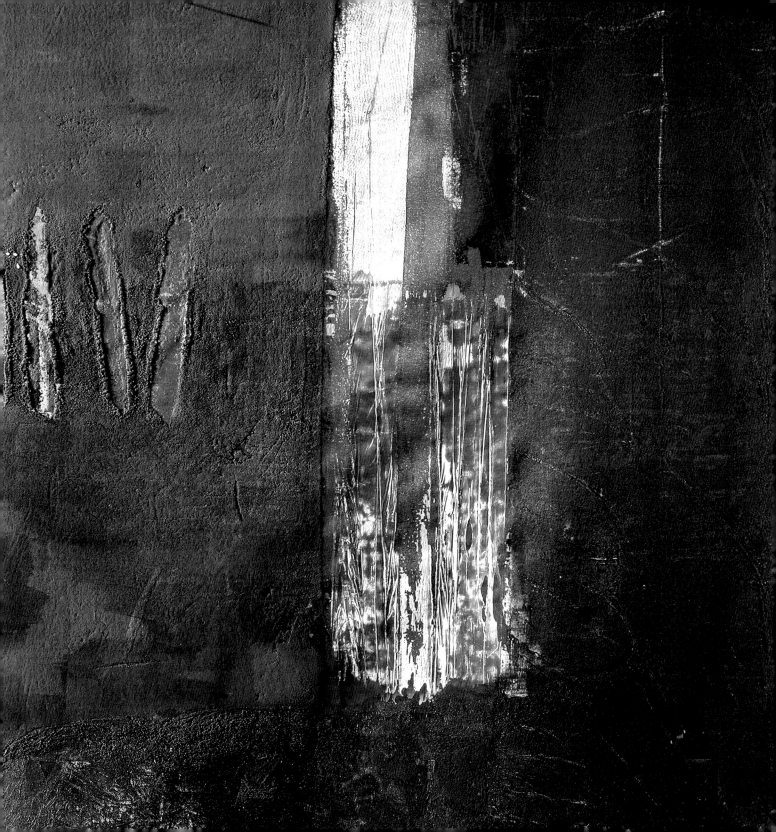

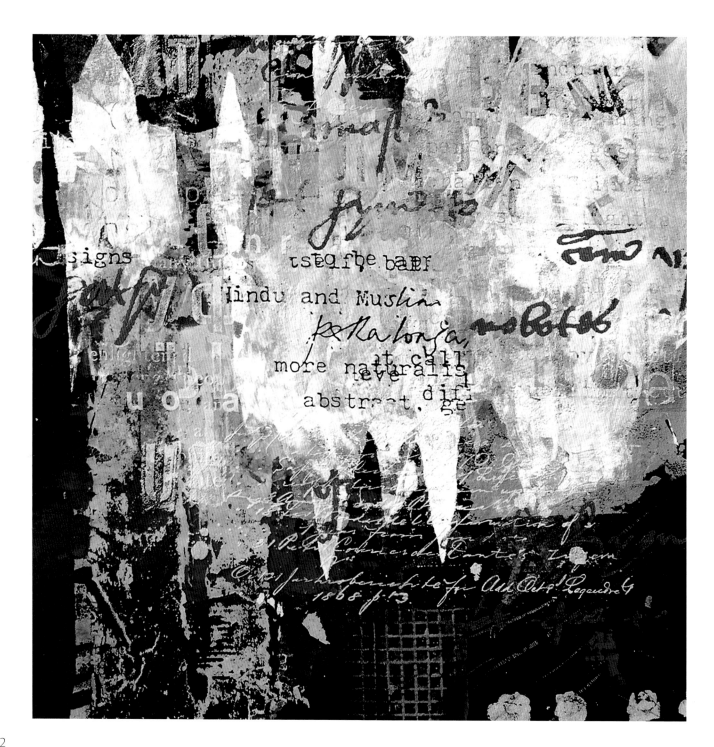

Voices in Mother Tongue II
(detail)
2003
digitally printed silk organza,
screen-printed with heat-reactive
pigment, various print media and
oxidisations
detail 40cm square
of full textile 54 x 360cm

pages 24 & 25:
Plaster Wall (detail)
1999
silk organza, printed with various
media and metal leaf
detail 54 x 27cm
of full textile work 54 x 360cm

and solids, light, shadow, texture
and subverted meaning that is
especially apparent in installations
of her panels, seen from both sides
and playing one against the other
(*Krefeld installation*, 1998).

While present in often-subdued
form in much of her work of the
past decade, the runic incantation
is uppermost in *Voices in Mother
Tongue* (1994) and *Voices in
Mother Tongue II* (2004). Together,
these two works also epitomize
Starszakowna's constant quest
with new techniques and her self-
questioning, 'Whether to stay with
an idea and develop it, and reap
the benefits of that idea, or to move
on to be an explorer.' [10] The first
employs one of Starszakowna's
signature methods: the use of
printed expantex (the rubbery
'puffa paste' used for logos on
T-shirts), over-worked with colour
and then raised with a heat gun,
causing the skin to break. The
second reflects her comment of
1997, the year in which she was
short-listed for the Jerwood Prize
for Applied Arts Textiles when she

remarked, 'I feel as though I am just
starting, ideas are always in your
head waiting. Letting them out at
the right time is the important
thing.' [11] It represents an entirely
new tangent, taken since 2001,
when she established the Research
Futures Unit at the University of the
Arts, London, in order to explore
the interface of digital and experi-
mental print processes, teasing out
the tensions between actual and
virtual reality on a textile substrate.

Other new directions in a literal
sense also presented themselves
in 1997, when Starszakowna
travelled to Japan, China and
Finland (the latter two for exhibi-
tions of her work) and began
a series on walls that comprise
a travel notebook. The journeys
these record include the *Plaster
Wall* series of 1997-99 [12] in which
some evoke scenes familiar to all –
'freshly skimmed plaster walls,
ridges left by trowel still felt:
luminous in the light' – and others
are more specific. Of *Walls of
Snow and Ice*, for instance, her
notes record:

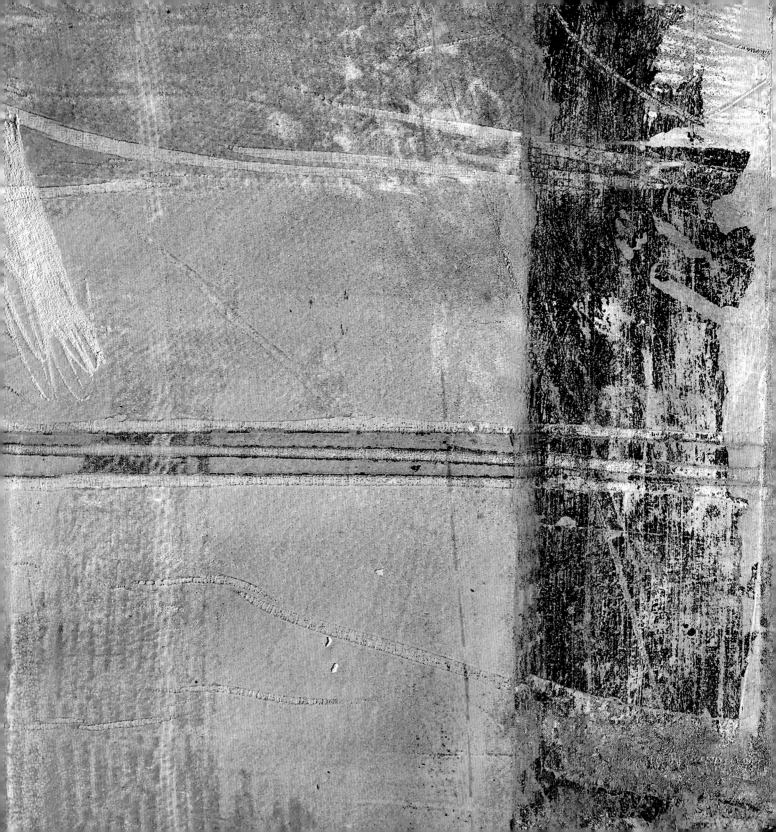

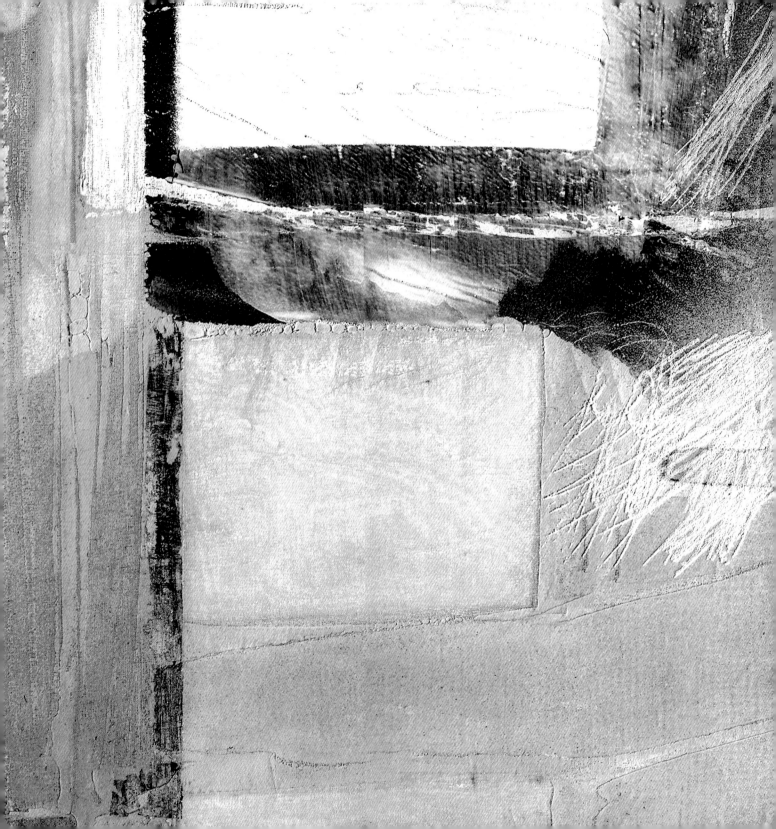

'landing in Rovaniemi, Finland, in the middle of winter, without luggage, so many different kinds of ice and snow on the runway and walls of buildings hard to determine what was snow and what was plaster or wood, little shards of metal fixtures poking through the skin of snow'

But they also include scenes from the past, as captured in *Blackface, Silence and Stakhanowitz* (1999), based on the coal-mining areas where Starszakowna spent the early part of her youth:

'watching men go down
in the cage
voices turned silent,
an oppressing fear
figures crawling on hands
and knees in the dark below
hearing the message of
Stakhanowitz' [13]

These pieces are among the evolving groups of textiles that have garnered increasing international acclaim during the past decade, as Starszakowna's work has been exhibited outside the UK in eleven countries, including in two solo shows in Japan in 1999, Korea's Cheongu International Biennale in 2002 and a solo show in the Dutch textile museum (Nederlands TextielMuseum) in Tilburg, in 2004.

In all of her recent textiles the metaphors for erosion abound. Change over time in places, ideologies and tongues is mimicked in the transmutation of cloth as it undergoes Starszakowna's labour-intensive process. Typically, this now involves printing on both sides of silk organza, screen printing heat-reactives, then glazing – creating translucent areas – and patinating for a rich metallic glimmer and additional thickness, seeking qualities that are reminiscent of a buried slide. Aside from the incorporation of the digital, she continues to add to her arsenal of colourations; *Acts of Beauty* (2000), for instance, incorporates silver leaf. Its intensely-wrought surface is emblematic of that ever present strand of duality, here by reference to the poignant remembrance of Fife's coal-mining community, 'Little Moscow', and the bleak promise of this region's return of Willie Gallacher, the longest-serving Communist MP ever elected to British Parliament, serving from 1935 to 1951.

In the search for meaning in her own personal landscape, Starszakowna has achieved two things. She is 'one of the few people who create fabric objects that constitute true art yet remain "usable".' [14] This feat shows itself readily in results such as the collection of scarves and prints for Shirin Guild Ltd (2002-03), but more tellingly in her installations, which make disciplined use of what is, essentially, yardage. For example, *Hinterland*, her recent permanent installation

Acts of Beauty II (detail)
2003
silk organza printed with heat-reactive pigment, various print media and silver leaf
detail 25cm square
of full textile work 54 x 360cm

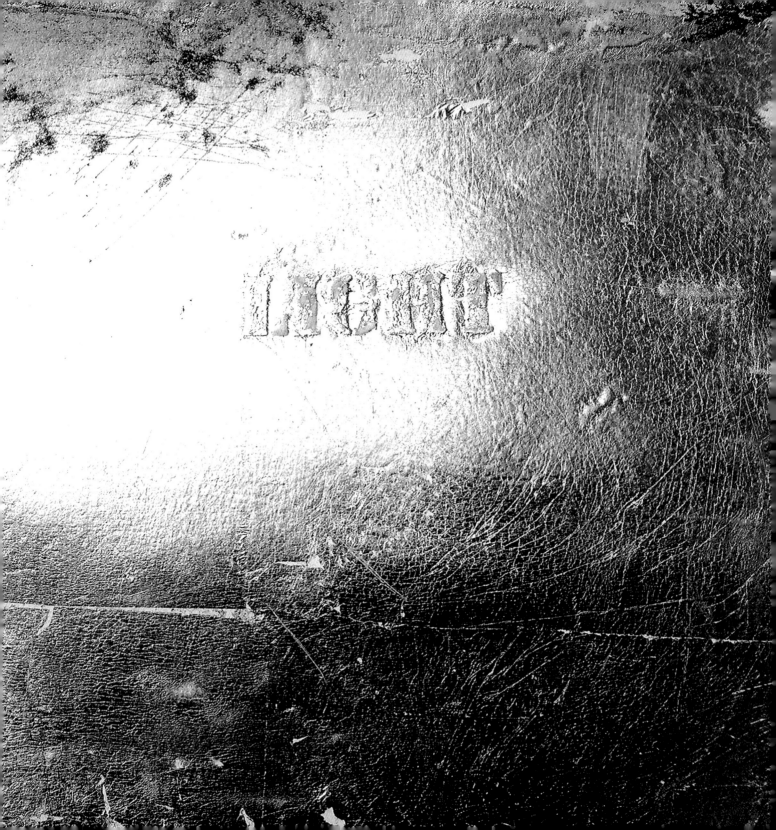

for the new Scottish Parliament building in Edinburgh, comprises 18 digitally and hand-printed textile sections suspended in a curved formation over an area of some 7 metres by 3 metres (23.5ft x 10ft). A commission won in 2003 following an internationally advertised competition, it consciously evokes the physical and social landscape of Scotland. 'Seductive and celebratory, the work evokes a proud and manifold cultural tradition'[15] and 'resonate[s] with metaphor, blending historical context with social issues.'[16] The respect for cloth, permeating *Hinterland* and all her work, underpins her second accomplishment. In seeking to capture the spirit of place and human endeavour, she has not only found her own authentic voice, but also the creative soul of printed textiles.

Mary Schoeser
Author, Curator

NOTES

1. Jean-Louis Ferrier (ed.), *Art of our Century* (Harlow: Longman Group UK Ltd), 1989, pp.650, 652.

2. 'The 60's', Norma Starszakowna (Dundee: Duncan of Jordanstone College of Art & Design) 1997 unpaginated catalogue, ISBN 899837-15-9.

3. Exhibition statement, 'Transmutations', TextielMuseum, Tilburg, Netherlands, 30 April-13 June 2004.

4. Anne Simpson 'A vivid talent shared', *Glasgow Herald*, 9 May 1990, p.28.

5. *International Textiles* 725, July 1991, special insert pp.xxxvii-xxxix.

6. 'Design Partnerships' (London: Design Council), 1987, a leaflet for this programme's launch at an exhibition/ conference at the Scottish Exhibition & Conference Centre (SECC). Design Bias (funded by the Scottish Development Agency, Scottish Education Department and regional government) undertook commissions for companies including the Arts Council, Burberry's, Bute Fabrics, BBC TV, Forbo-Nairn and Marks & Spencers, and through the Scottish Office and Foreign Office had work presented to groups of international journalists from as far afield as India and China.

7. 'Putting Design in its Place', *Design*, October 1986, p.28.

8. Simpson, op.cit..

9. 'Cut from a finer cloth: the Anne Simpson interview', *The Herald*, 3 February, 1997, p.14.

10. Beatrice Sayers, 'Ripping yarns', *The Scotsman*, 3 June, 1995, p.33.

11. Margot Coatts, 'Sources of Inspiration', *Crafts* 146, May/June 1997, p.49.

12. Acquired for the collection of Reiko Sudo of Nuno Corps., Tokyo.

13. Stakhanowitz, 'hero' of the Soviet Five-Year Plan in the 1950s and progenitor of time and motion studies, gave his all to help rebuilding after WWII, until his 'comrades' took a hammer to his hands.

14. 'Three textile artists in Tilburg', *TextileForum* 2/2004, p.13.

15. Philippa Swan, 'Commissions: Works for the new Scottish Parliament building', *Crafts* 192, January/ February 2005, p.29.

16. Ian Gale, 'Wanted: Holyrood stooge', *Scotland on Sunday*, 21 November 2004, p.3, or http.//news.Scotsman.com/print.cfm ?tid=177&id=1337962004

Acts of Beauty III (detail)
2003
silk organza printed with heat-reactive, various print media and silver leaf
detail 25cm square
of full textile work 54 x 360cm

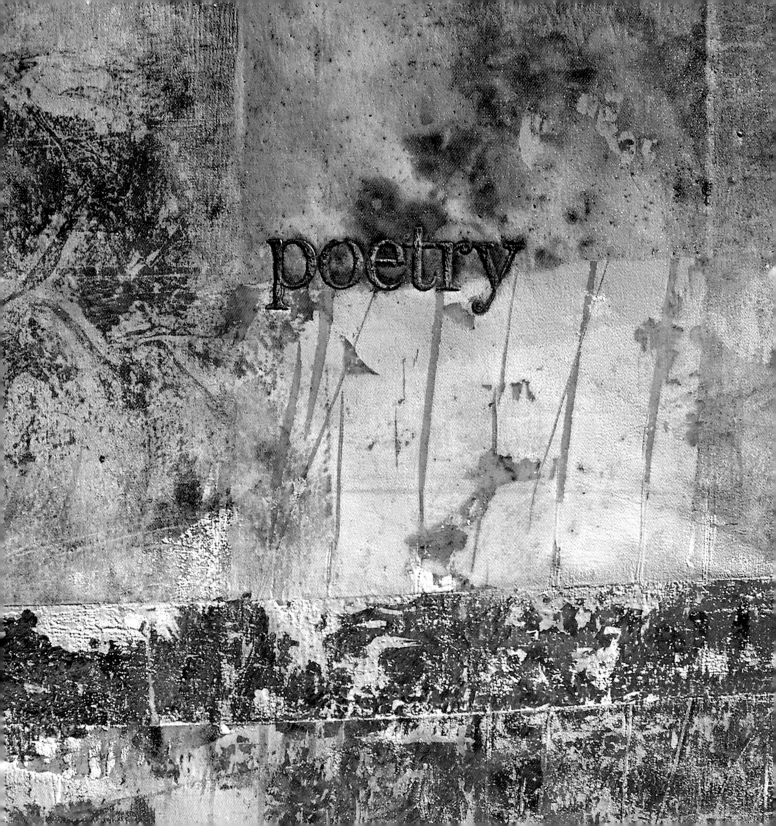

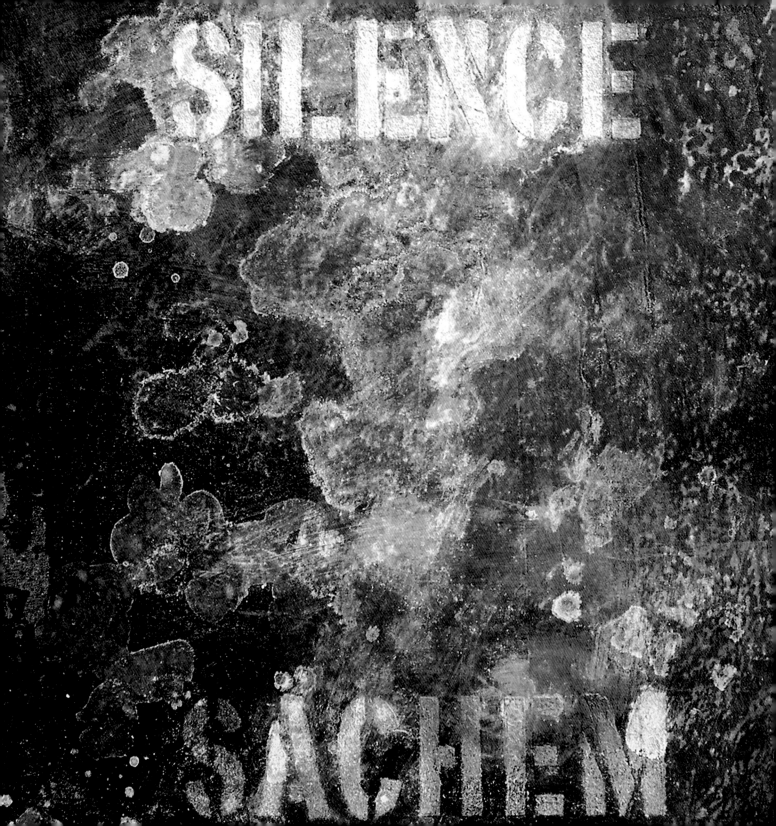

Colour Plates

**Blackface, Silence and
Stakhanowitz** (detail)
1999
silk organza, printed with heat-
reactive, various print media
and oxidisations
detail 25cm square
of full textile work 54 x 360cm

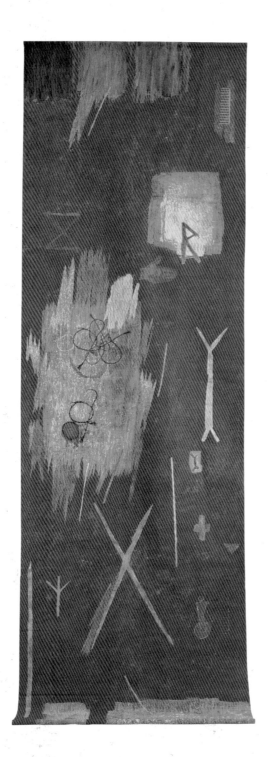

Red Rune Wall
1997
cotton satin screen-printed
with heat-reactive pigment
and various media
122 x 360cm

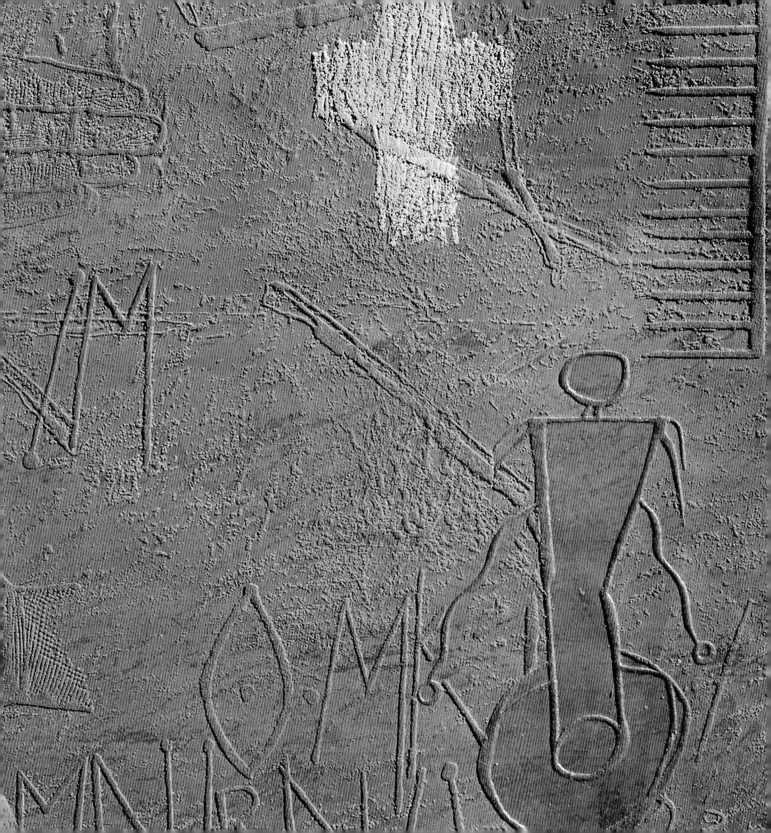

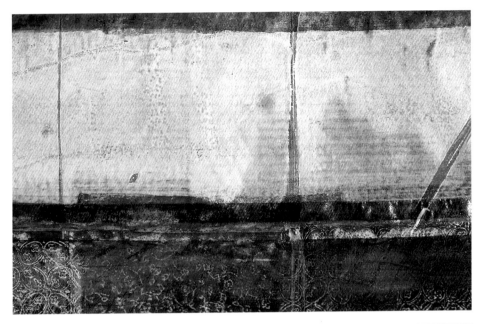

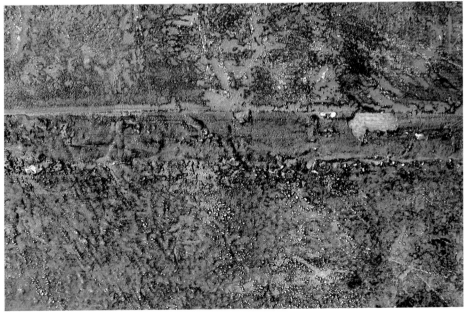

page 34, from left to right:
Rice Field
China Sunset
Red Stripe
1999
silk organza, screen-printed
with heat-reactive pigment,
various print media
25 x 360cm each

page 35:
Stripped Wall (two details)
1997
silk organza, screen-printed
with heat-reactive pigment,
various print media
122 x 360cm

opposite:
Pink Stripe (detail)
1999
silk organza screen-printed
with heat-reactive pigment,
latex and various print media
detail 20cm square
of full textile 53 x 360cm

pages 38 & 39:
Blue China Wall (detail)
1998
silk organza screen-printed with
various media
detail 54 x 27cm
of textile work 54 x 360cm

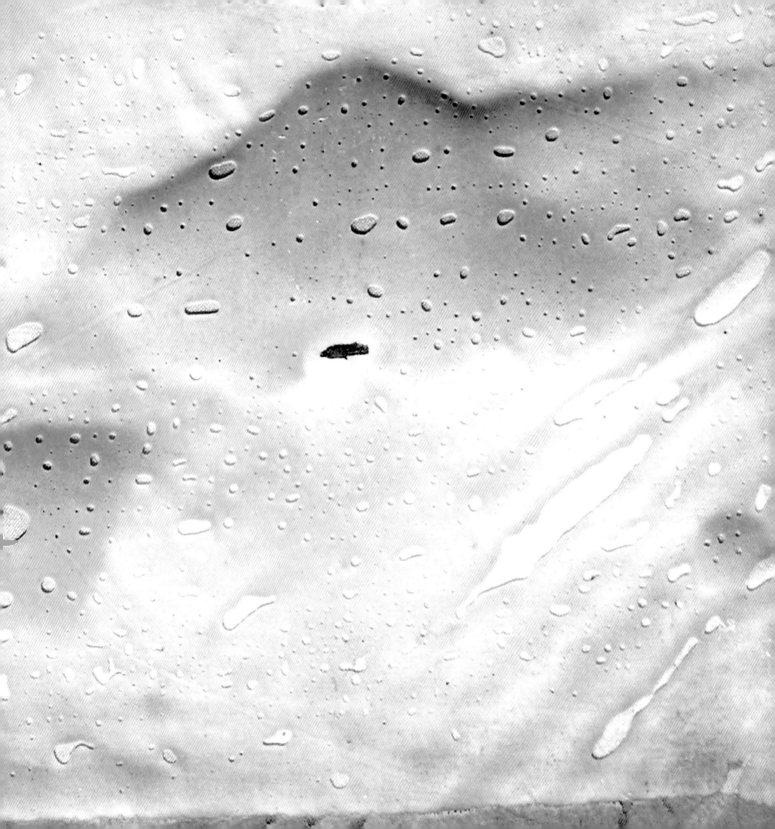

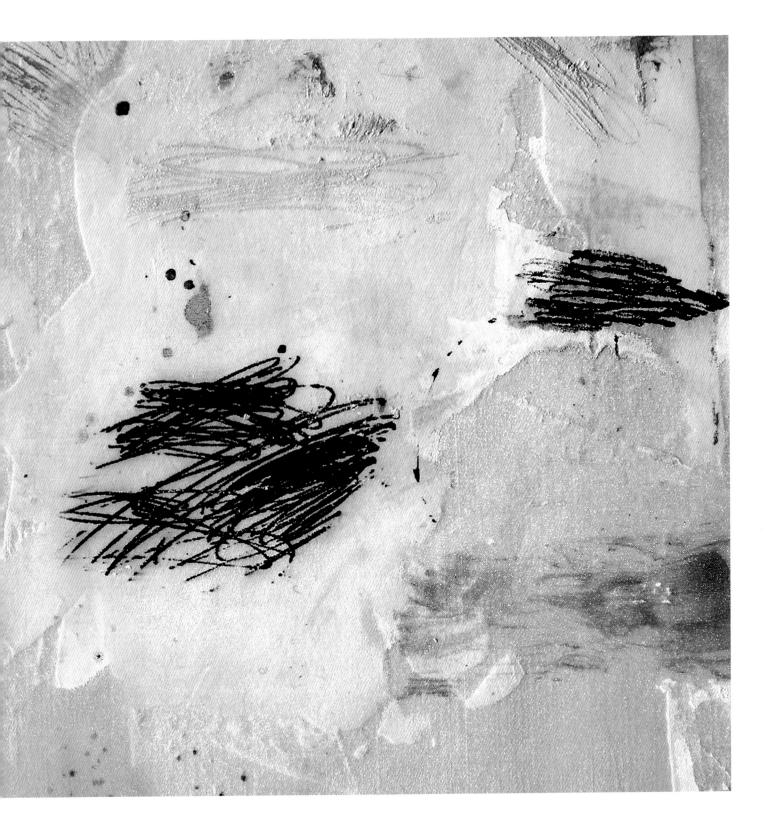

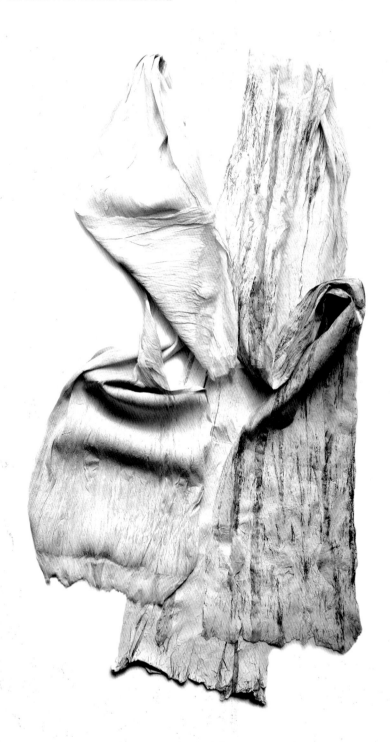

**Scarves for Shirin Guild
Spring/Summer Collection** (detail)
2003
hand patinated and pleated silk
crepe de Chine, screen printed
with pigment
artwork consists of three scarves
approx. 34 x 220cm each

right:
Fashion fabrics (detail)
2004
hand patinated and manipulated
detail top & right: 45 x 45cm
detail bottom left & right: 10 x 10cm

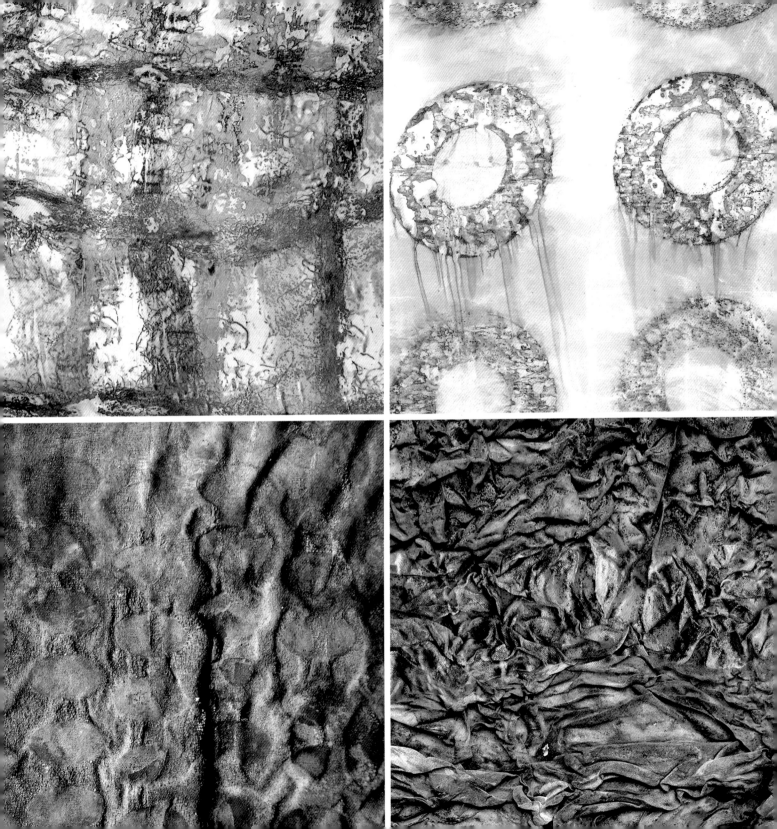

Artist's Commentary:
Hinterland, Scottish Parliament
Commission

Commissioned by the Scottish
Parliament and Art in Partnership
and installed in the new Scottish
Parliament in September 2004,
the *Hinterland* installation reflects
Scotland's landscape, industries,
its cultural history and tradition
of innovation that ranges across
the sciences, engineering, educa-
tion, economics, communication
and philosophy. The installation
comprises a sequence of eighteen
sections of translucent organza,
each digitally and screen-printed
on both sides with various heat-
reactive media, glazes, patinations
and metallic leaf. Graduating in
width from left to right, each
section is suspended at right-
angles from a curved wall so that,
in addition to each section being
'readable' from different perspec-
tives, light is refracted through the
installation as a whole, reflecting
qualities of translucency, shadow,
textures and colour, optimising
its function as a colour field.

Hinterland
2004
installation
digitally printed silk organza,
screen-printed with heat-
reactive pigment, various
print media and metal leaf
18 textile sections
each 260cm in height
graduating in width from
17cm on left to 59cm on right

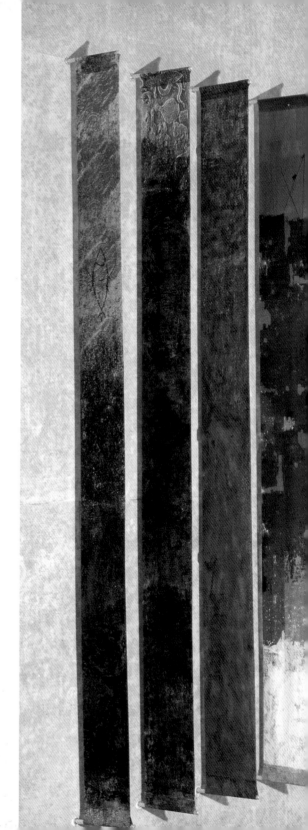

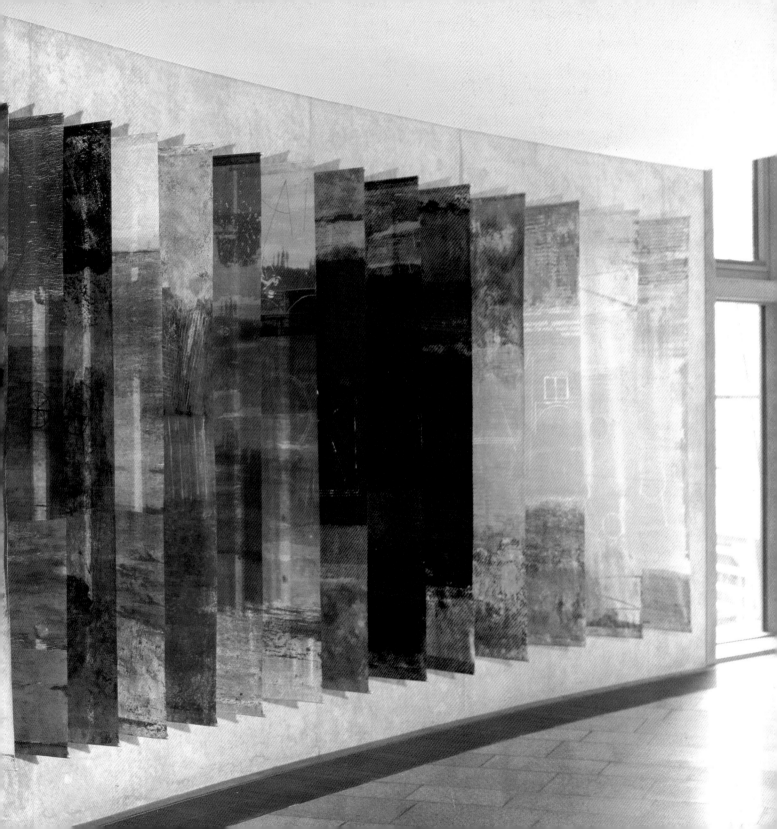

Selected Solo Exhibitions

2004	'Transmutations - Norma Starszakowna', The Dutch TextielMuseum, Tilburg, Netherlands
2003	'Textiles by Norma Starszakowna', Invited Artist, St Katherines Gallery, Gdansk/University of Lodz, Poland
1999	'New Textiles by Norma Starszakowna', Sembikiya Gallery, Tokyo, Japan
	'New Textiles by Norma Starszakowna', GalleryGallery, Kyoto, Japan
1986	Anatol Orient Gallery, London
1981	'Recent Works by Norma Starszakowna', Hendersons Gallery, Edinburgh
1971	'Norma Starszakowna', Compass Gallery, Glasgow

Selected Group Exhibitions

2003	'Artists at Work: New Technology in Textiles', Museo del Tessuto, Prato/Florence, Italy
2002	Cheongju International Biennale, shortlist, international juried exhibition, Cheongju, Korea
1999	'New Ways of Seeing', Royal Museum of Scotland, Edinburgh
1998	'Vision & Reality', Deutsche Textil Museum, Krefeld, Germany
	Joint 'CC Profile Exhibition', with A. Brittain, D. Hogg, V&A Museum, London
	'PRINTBANK', Indigo at Premiere Vision, Paris
1997	'International Textiles', Kuopio Museum, Kupio, Finland
	'Jerwood Prize for Applied Arts' Exhibition, Crafts Council/Jerwood Foundation, London
	'International Exhibition', Guizhou Museum, Guiyang, China
1995	'Designers Habitats', Collins Gallery, Glasgow
1995-96	'Raw Materials', Scottish Arts Council Touring Exhibition
1994-95	'Colour into Cloth', Crafts Council, London, Bath Museum, Whitworth Art Gallery, Manchester
1982	'Contemporary British Crafts' (Crafts Council), Houston, USA
1981	'13 Craftsmen', Rohsska Museum, Gottenburg
1980	'New Faces', British Craft Centre, London
1977-85	'Glasgow Group', McLellan Galleries, Glasgow; Scottish Craft Centre, Edinburgh; Aspects Gallery, London
1977	'New Acquisitions' Scottish Arts Council, Edinburgh
1976	'Great British Crafts', Crafts Council/Heals, London
1973	'The Craftsman's Art', Victoria & Albert Museum, London
1968	Hammond House Museum, New York

Selected Public Collections

Reiko Sudo/Nuno Corporation, Tokyo
Scottish Arts Council
IBM Collection
Leeds City Art Gallery
Aberdeen City Art Gallery
Sembikiya Gallery, Tokyo
Deutsche Textil Museum, Krefeld, Germany

Selected Commissions

2004	'Hinterland', permanent installation 2.5 x 7 metres, via UK competition commissioned by Scottish Parliament, Scottish Parliament Building, Edinburgh
2002-2003	Design collection commissioned by Shirin Guild, retailed Liberty, Harvey Nichols etc.
1995	Winner, Scottish Arts Council Competition, Interior Commissions Project Commissioned by 'Dovecot Studio Rugs', Edinburgh Tapestry Company, RSA Gallery, London
1990-92	Commissioned by Issey Miyake and Ann Sutton/Winchester Cathedral Projects
1982-83	'Silk Wall' (30'x 9') commissioned by J Parr & Partners, architects, for World Headquarters of General Accident Assurance Co., Perth. Awarded Saltire 'Art in Architecture Award'

Selected Publications and Reviews

2005	*Techno Textiles 2* by S.Braddock, pub.Thames & Hudson
1997-2005	*Crafts*, reviews (Jan.'05, June '97, Aug.'97, Oct.'97), pub.Crafts Council
2005	*Artists at Work*, catalogue, pub. Museo del Tessuto, Italy
2001	*The International Design Year Book 2001*, pub. Lawrence King Publishers Ltd
1998	*Techno Textiles: Revolutionary Fabrics* by S.Braddock & M. Mahoney, pub.Thames & Hudson *Fabric Dyeing & Printing* by K. Wells, pub. Conran Octopus
1997	*Seushoka-A*, article by S. Fukomoto, pub. Maruzen Co. Ltd, Tokyo, Japan *Jerwood Prize (Textiles)*, catalogue, pub.Crafts Council
1995	*Colour into Cloth*, catalogue, pub.Crafts Council
1985	*British Craft Textiles* by Ann Sutton, pub. Orbis
1985-2005	*Research Papers* presented and published by Marmara University (IITC 2005) Istanbul, Turkey; University of Zagreb (ITC&DC 2002/4); University of the Arts Philadelphia (Design & Technology Conference 2004) USA; University of Wodz (AUTEX 2003) Poland; V&A (Fashion in Motion 2001) UK; Institute Dell'Arte and Mantero Ltd (International Lectures 2002), Italy

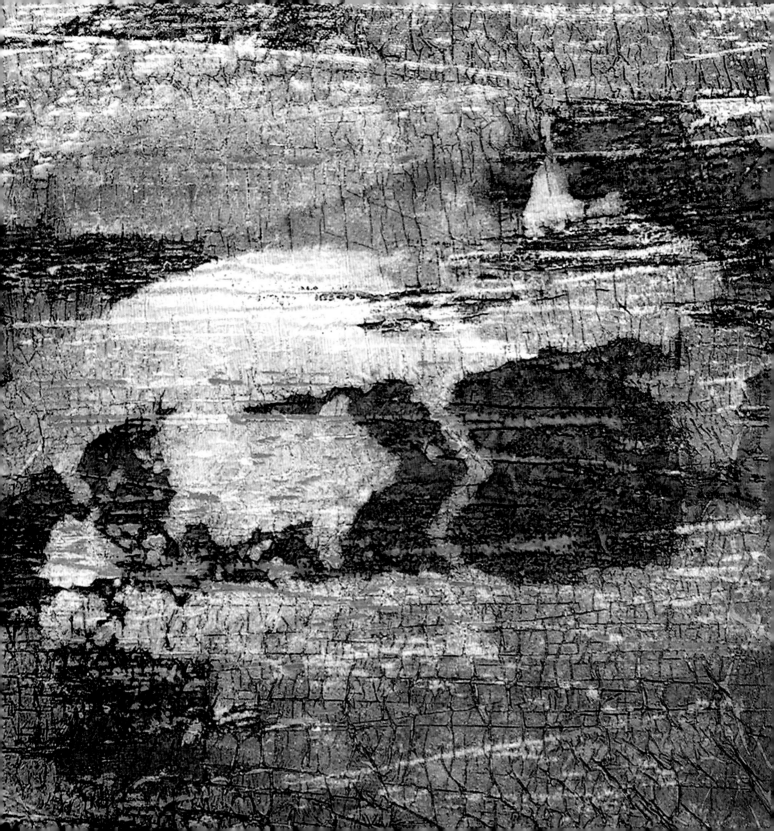